The
Kittens
Coloring Book

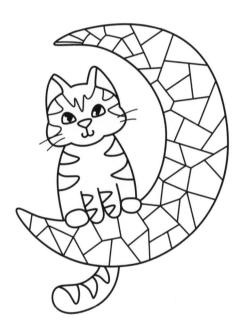

The
Kittens
Coloring Book
Cosy up with these adorable furry felines

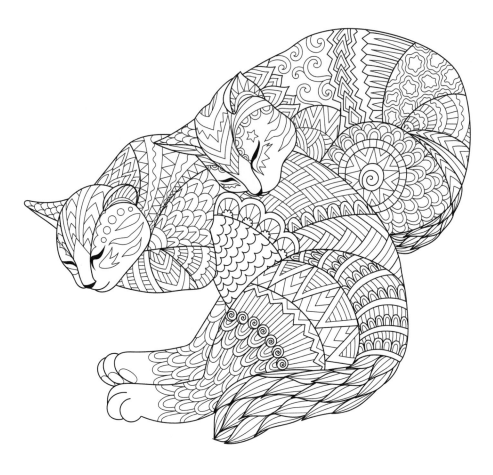

SIRIUS

SIRIUS

This edition published in 2023 by Sirius Publishing, a division of
Arcturus Publishing Limited,
26/27 Bickels Yard, 151–153 Bermondsey Street,
London SE1 3HA

ISBN: 978-1-3988-2772-1
CH011154NT
Supplier 29, Date 0623, Print run 00003263

Printed in China

Introduction

With their large eyes and ears, soft fur, and sheer joy at exploring the world, kittens are among the most adorable of baby animals. Whether sleek or fluffy, slender or cuddly, most people are simply enchanted by a kitten's playful energy. Gathered here are a delightful selection of kittens sleeping, playing, gamboling, climbing, and generally making mischief. Some are cute cartoons, others ornately decorated with patterns, or appearing as part of a special kitten mandala. If you're a devoted cat slave or someone who just enjoys them from afar, there should be images that appeal in this varied selection. Whether or not you are accompanied by a feline friend, select an image that you know you'll enjoy coloring, seek out your best spot for relaxation, take your colored pencils and begin to create a whole houseful of wonderfully colorful kittens.

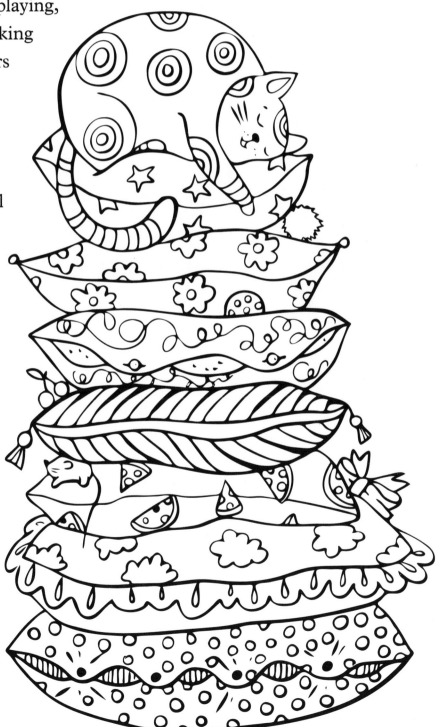

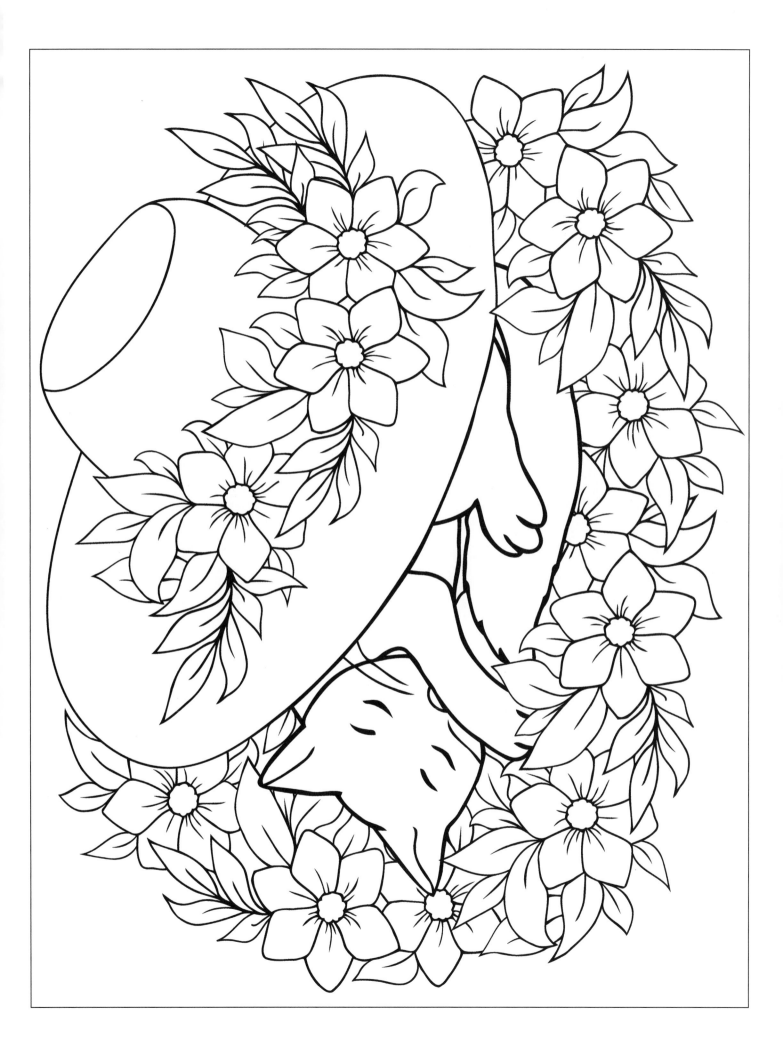

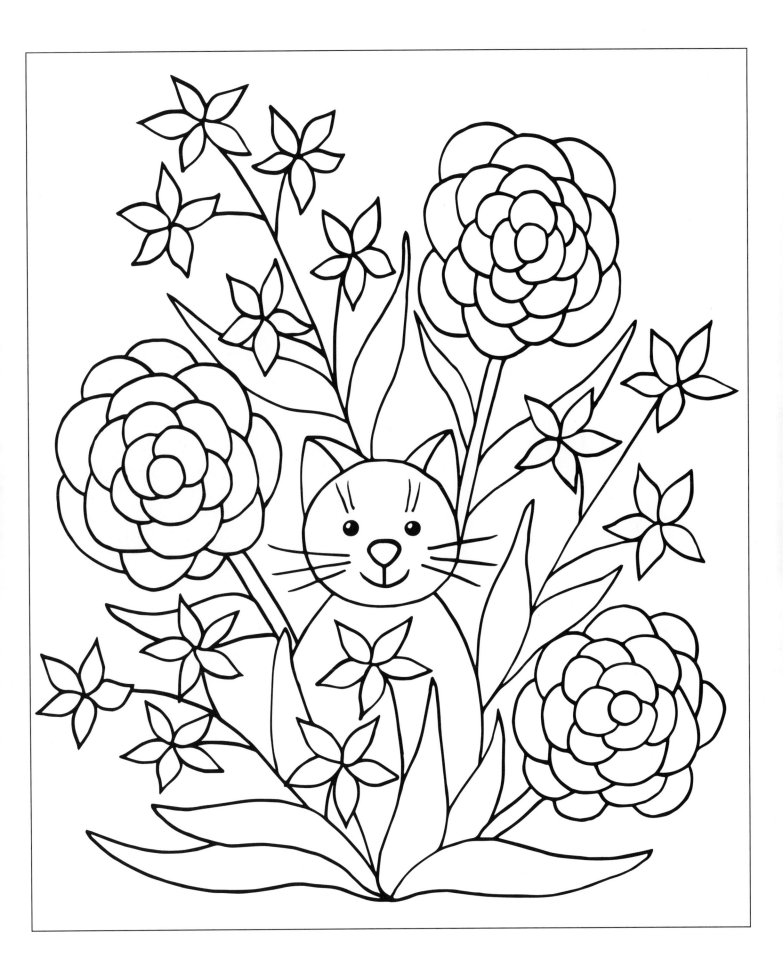

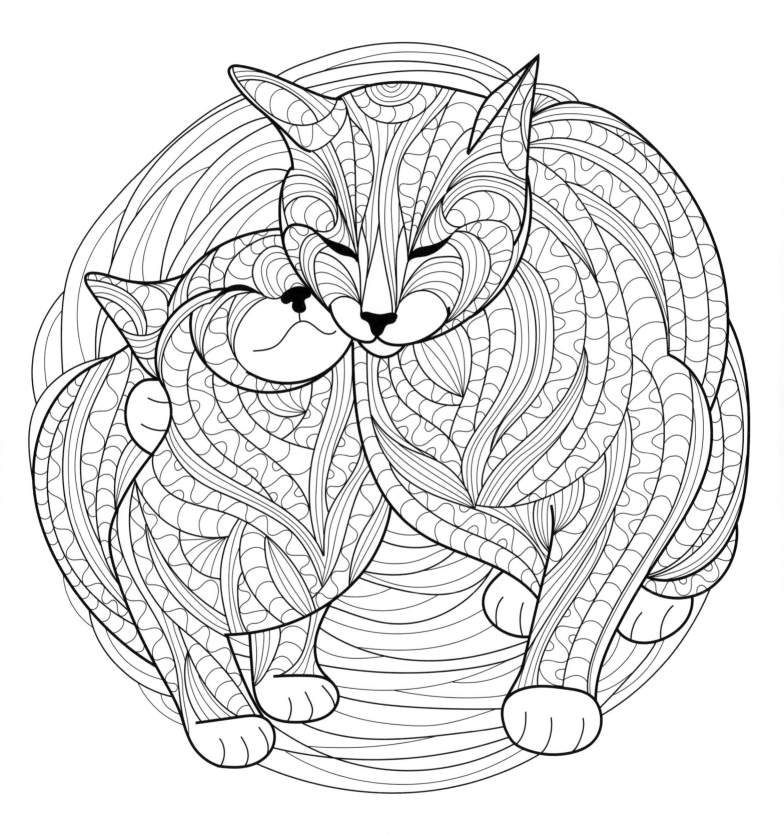

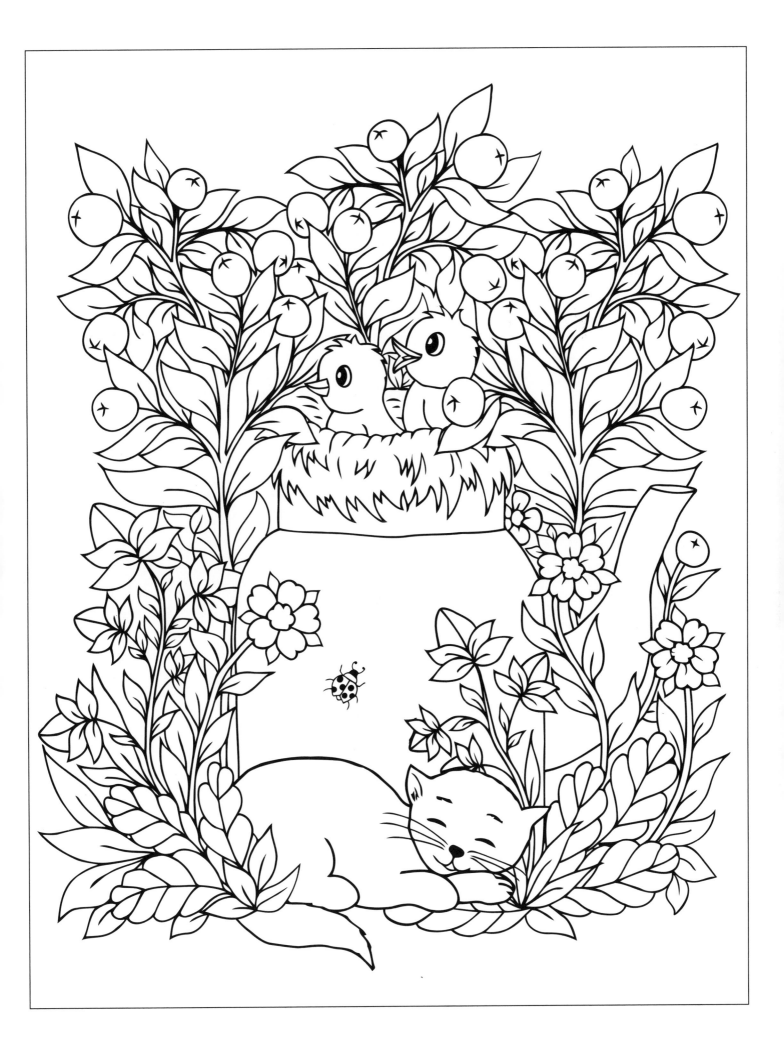

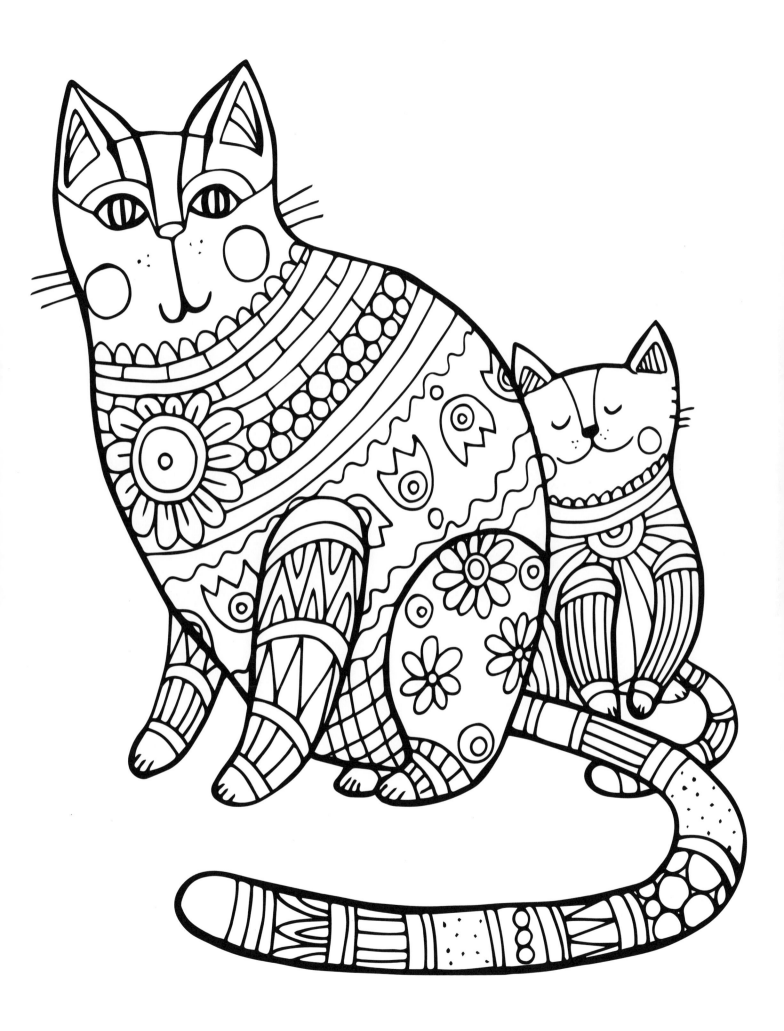

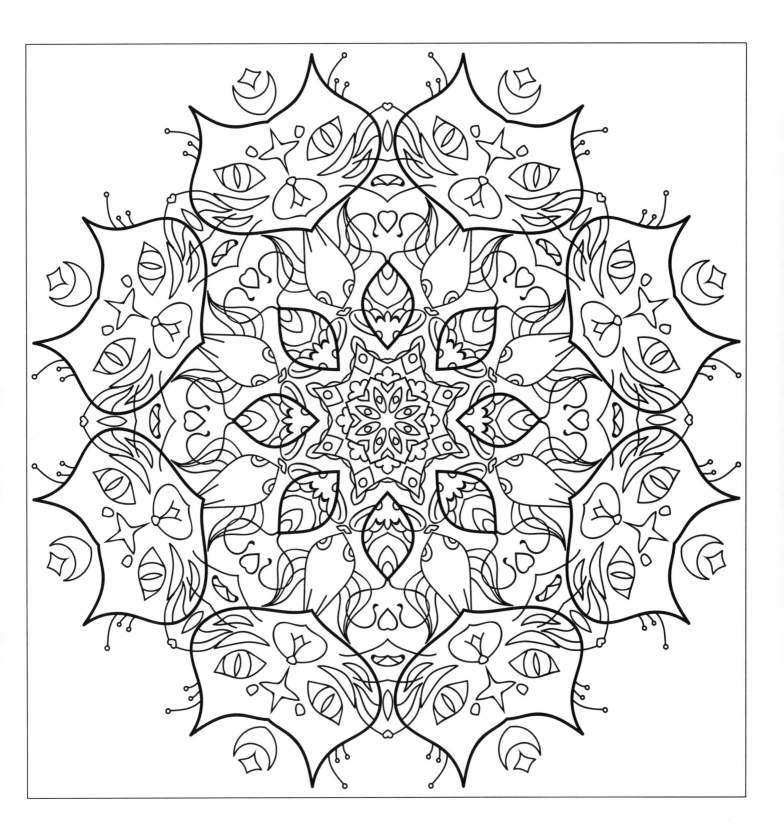

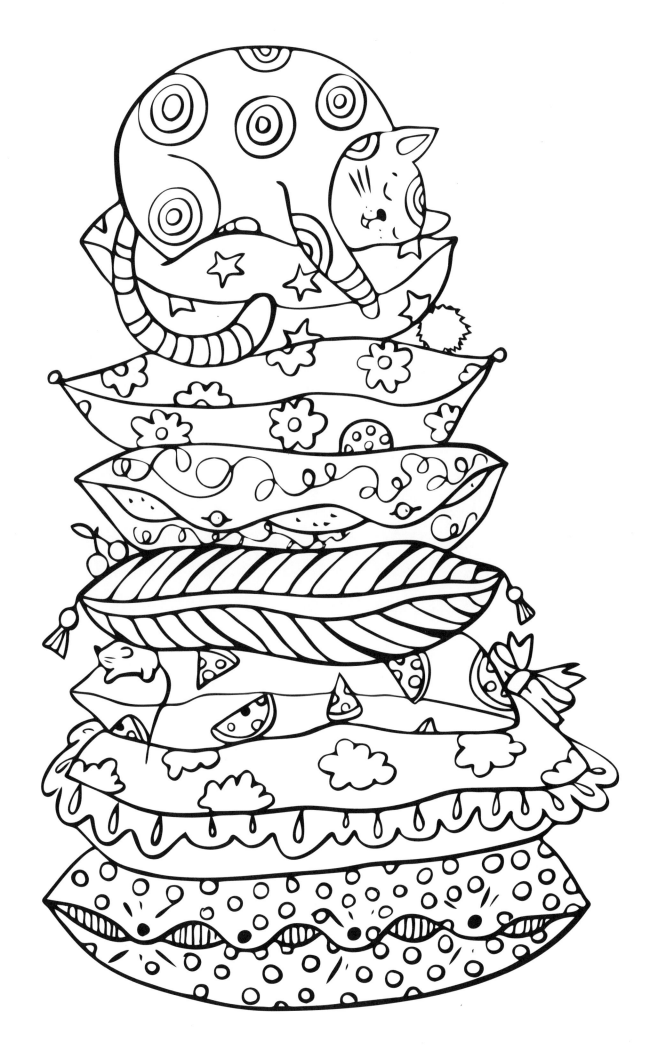

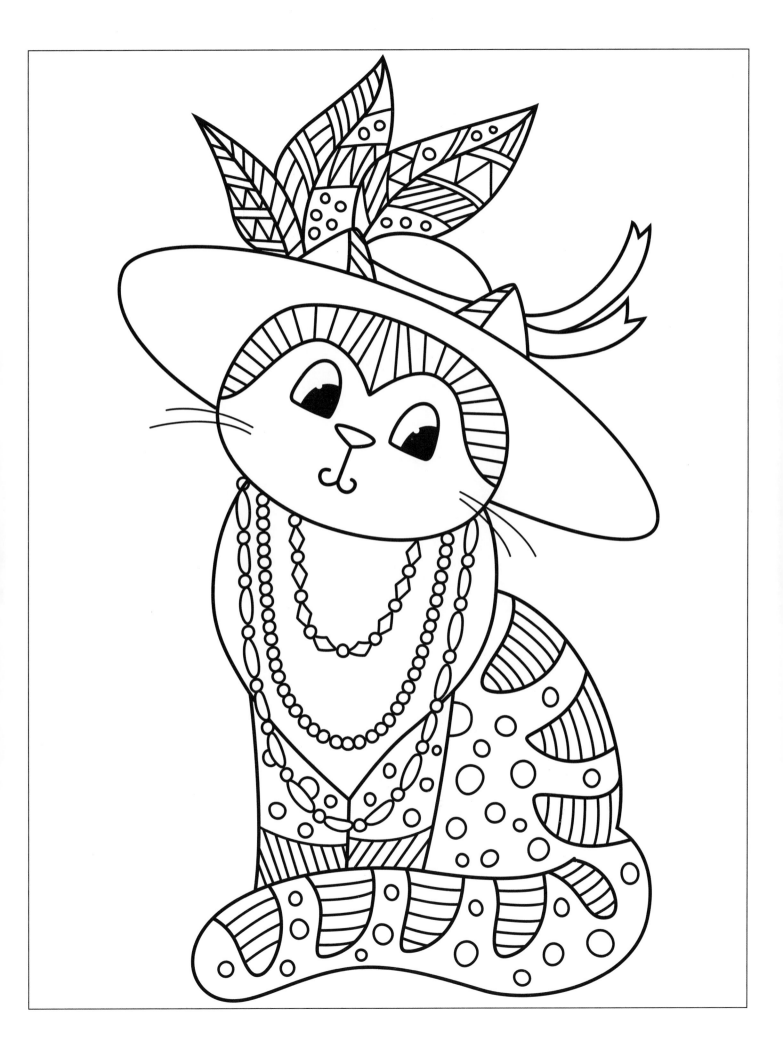

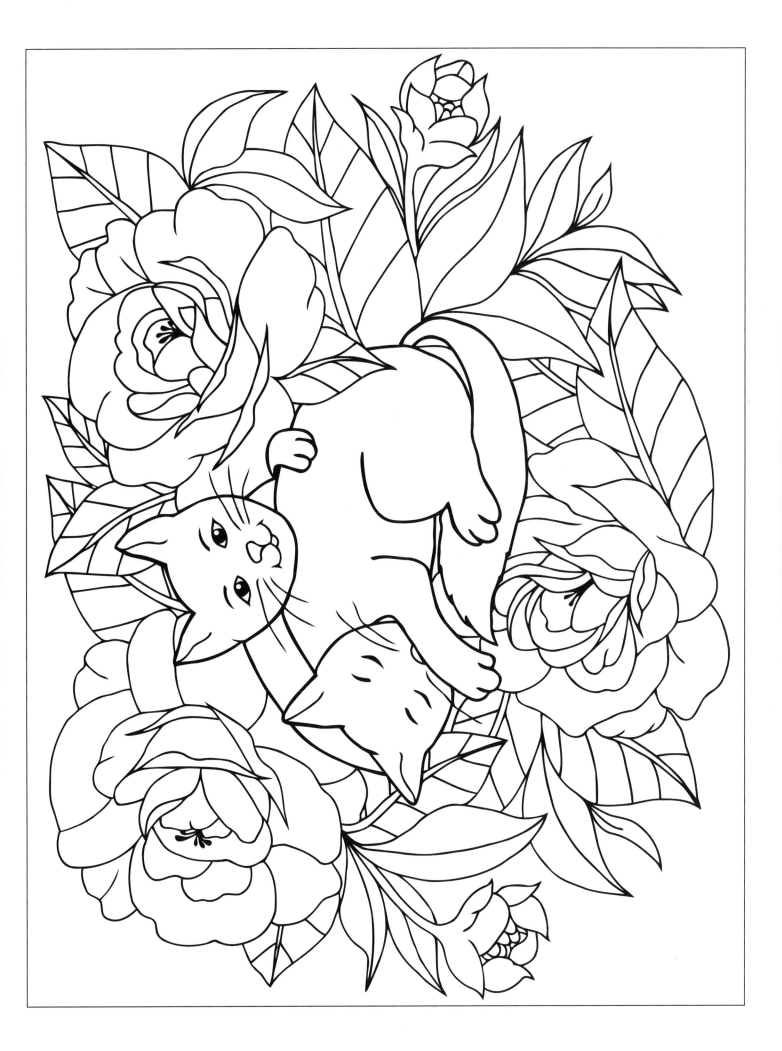

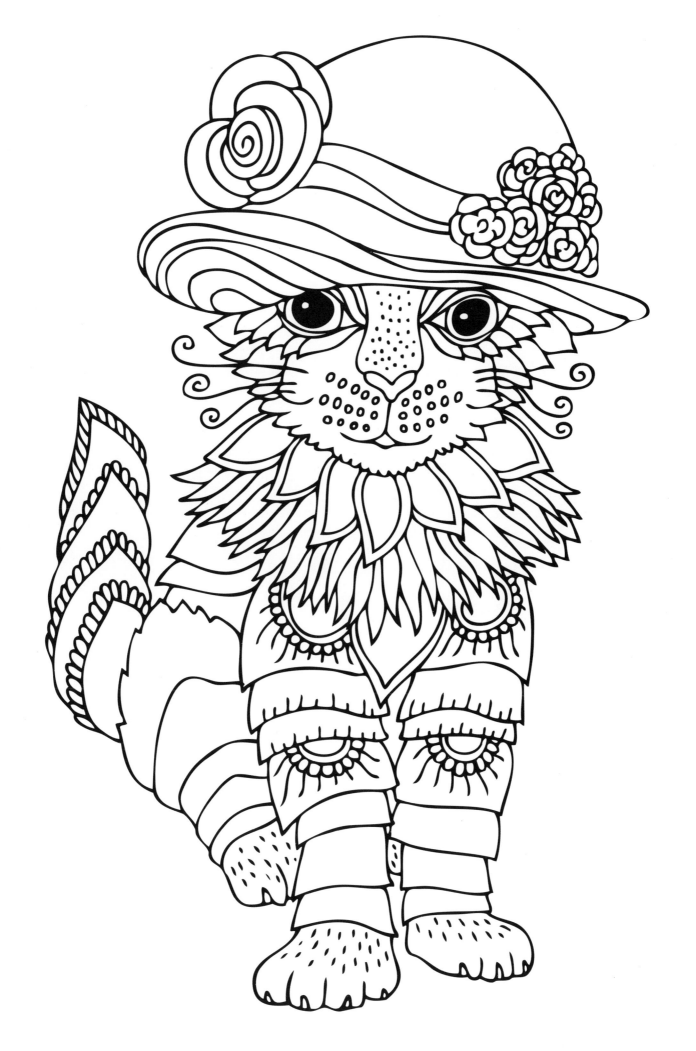

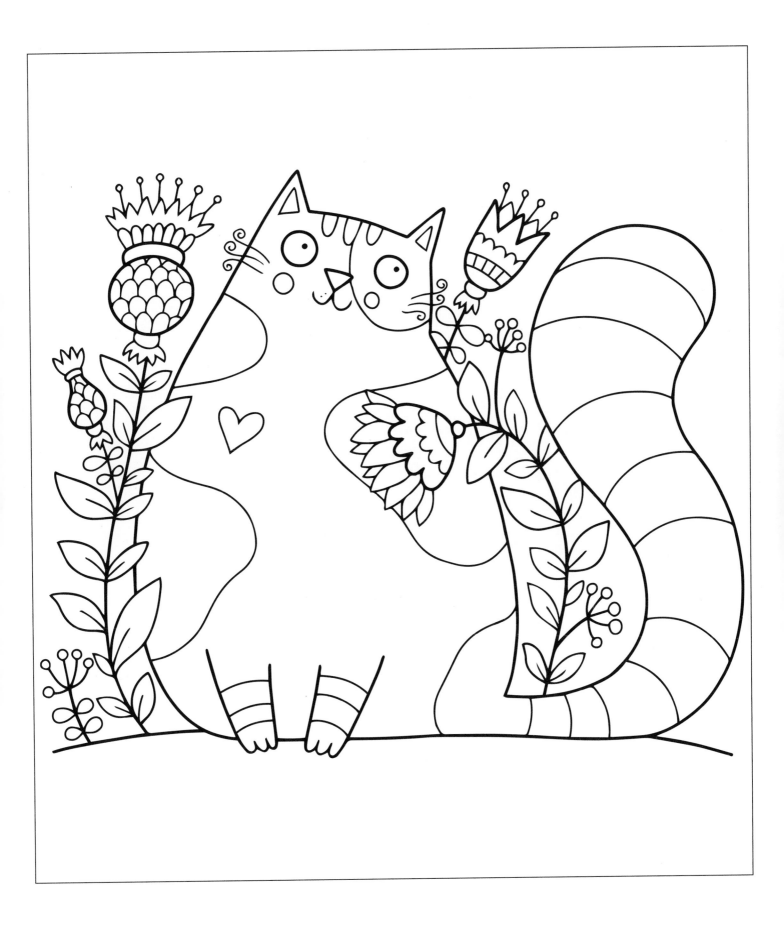

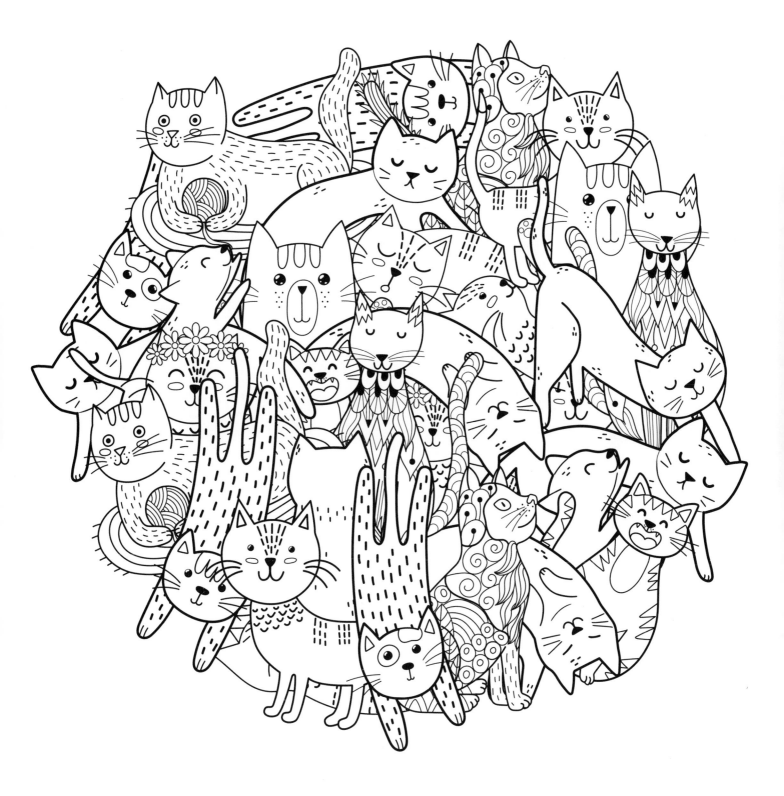

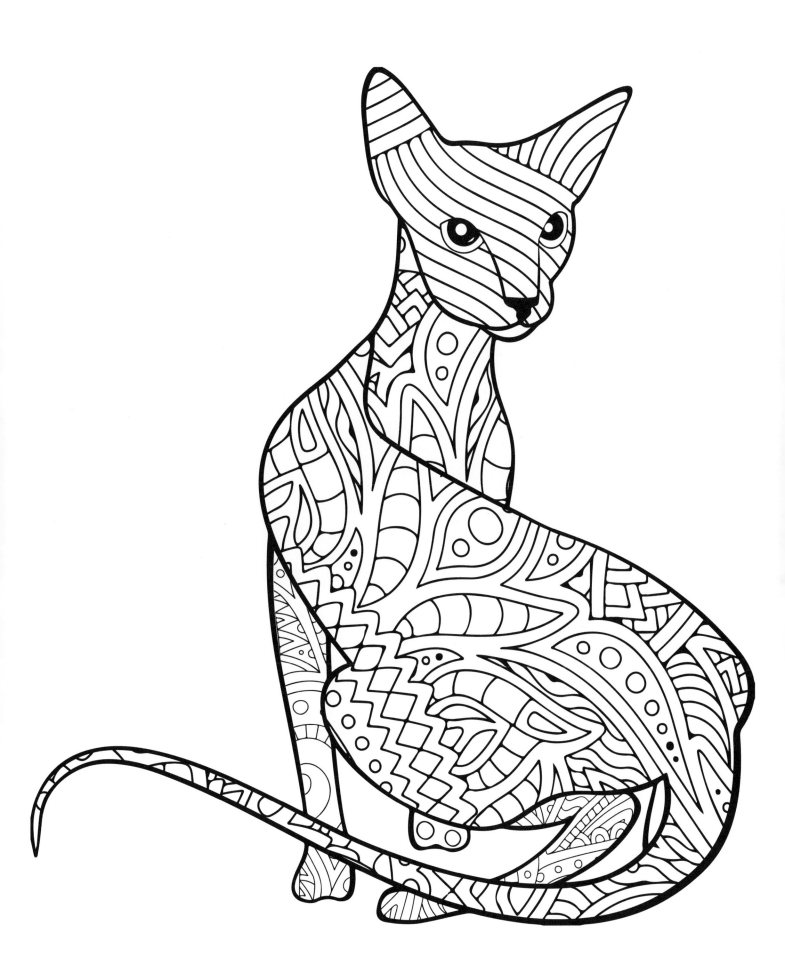

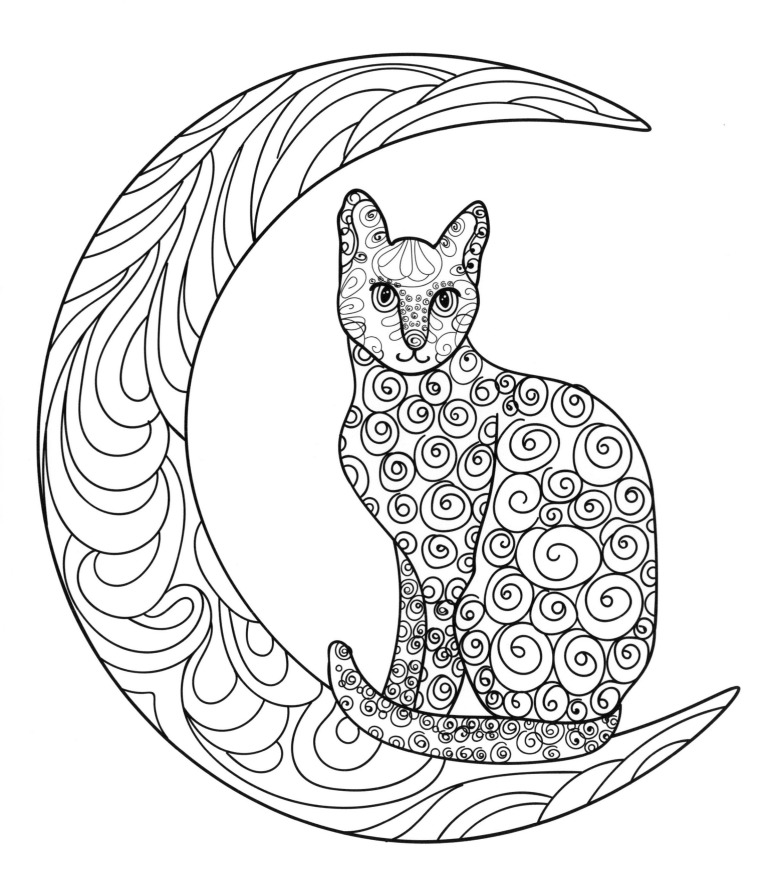

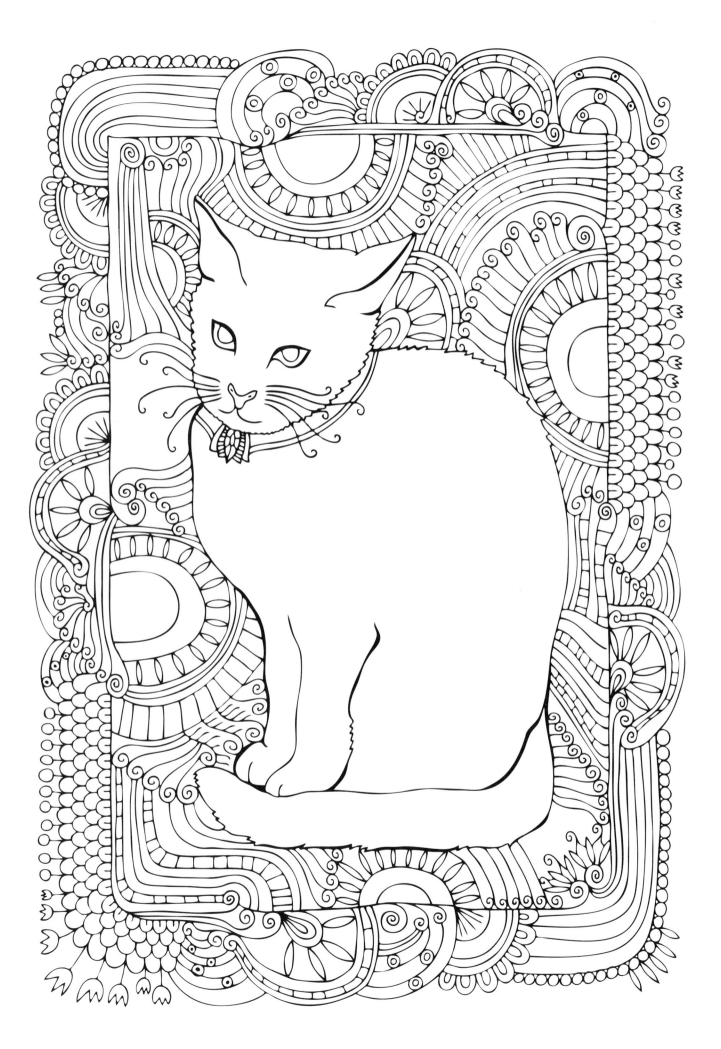

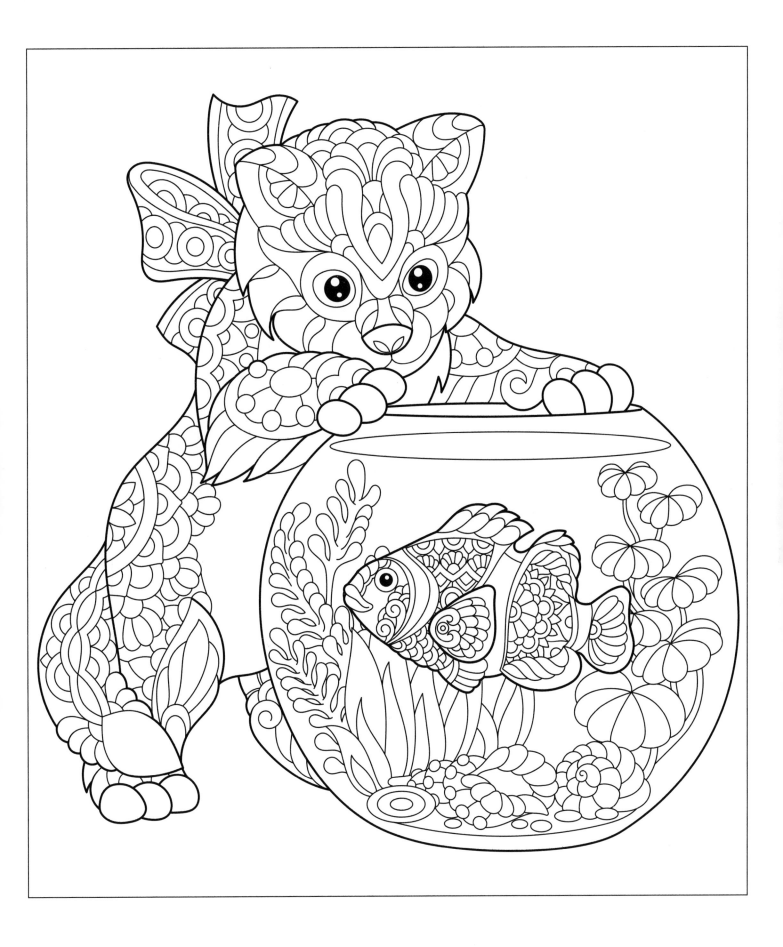

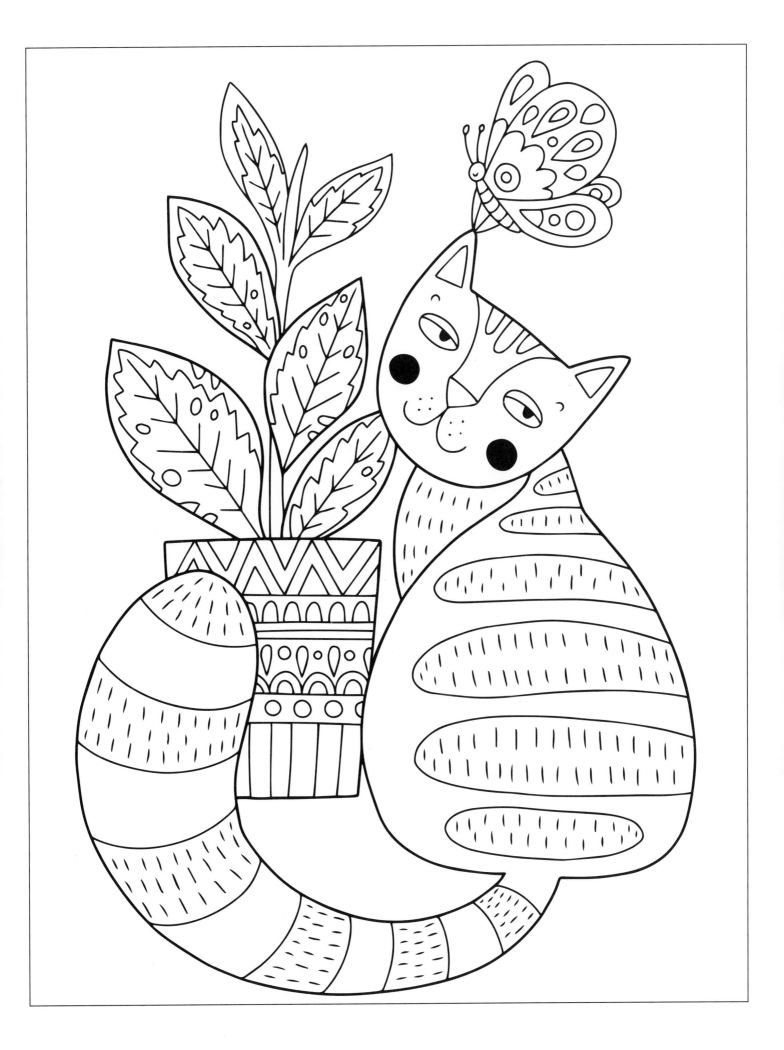

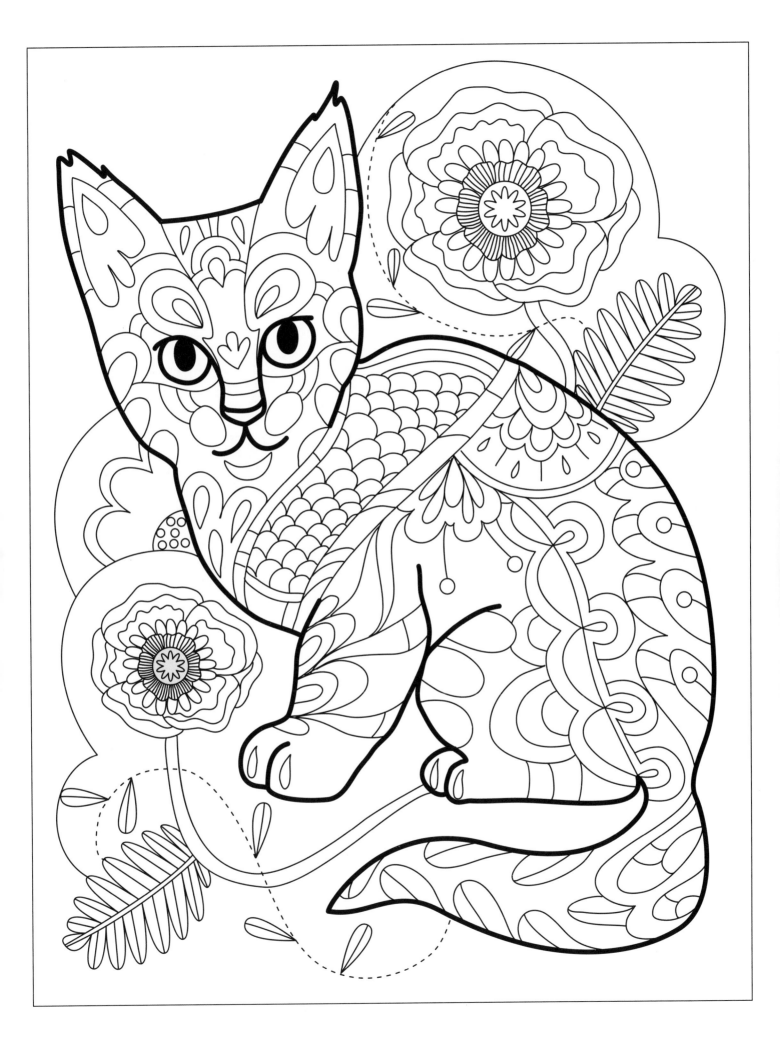

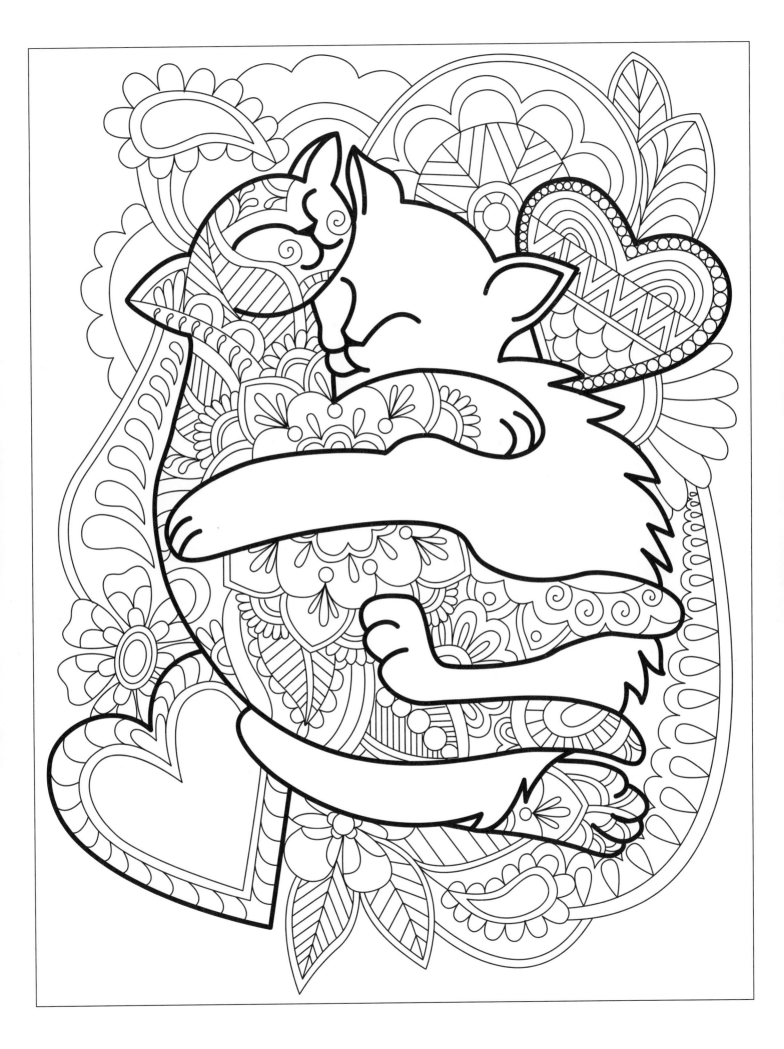

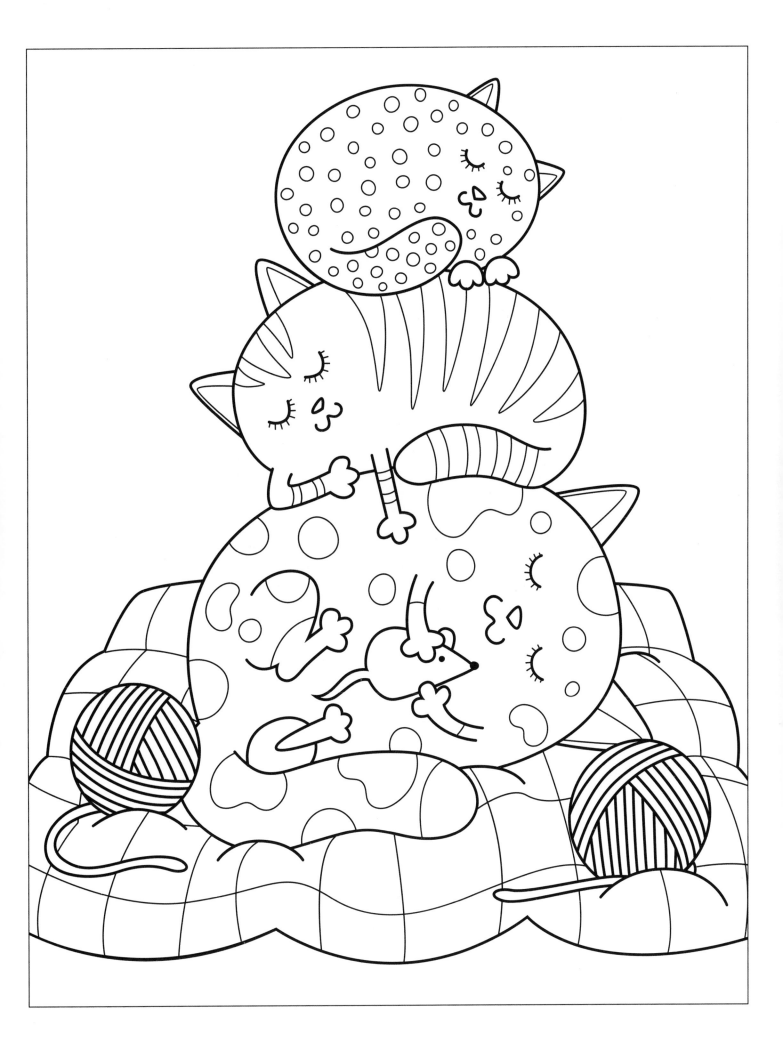

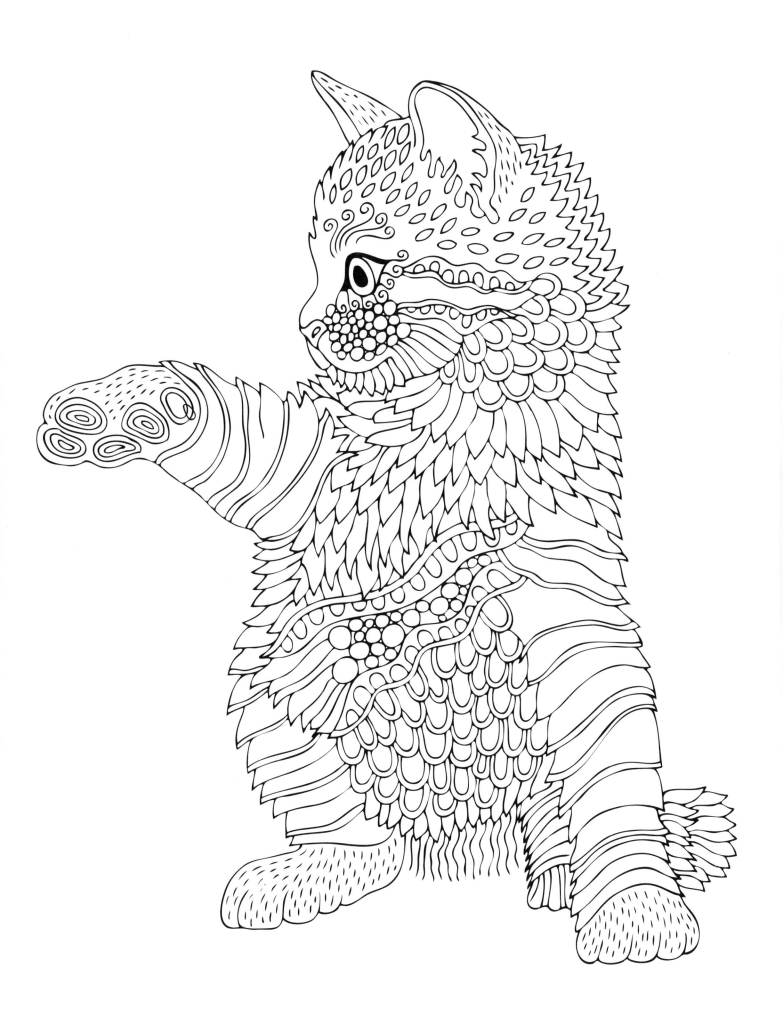

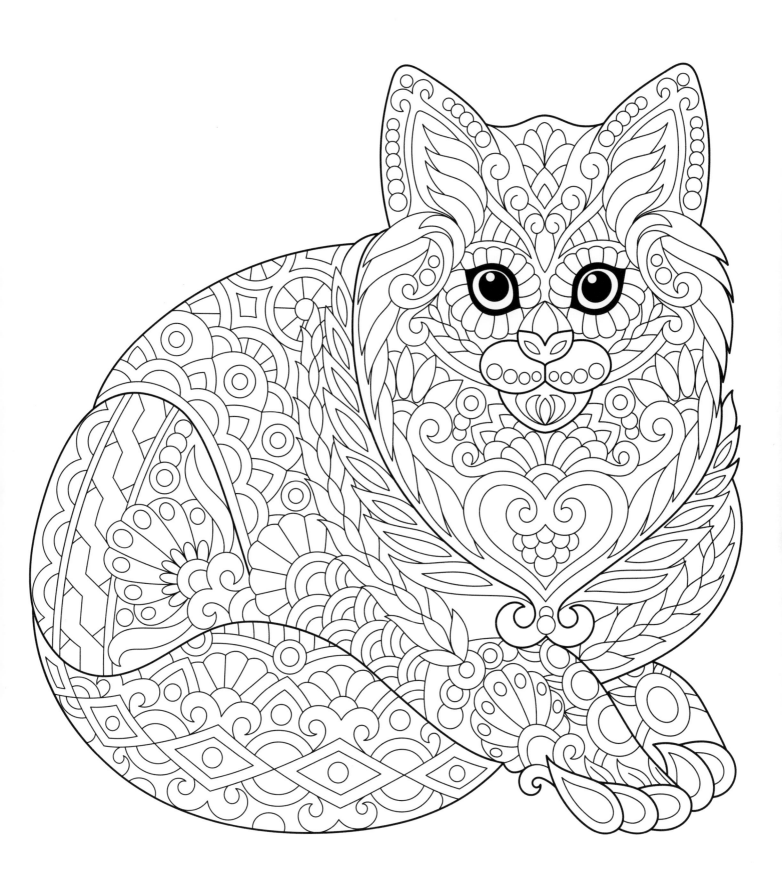

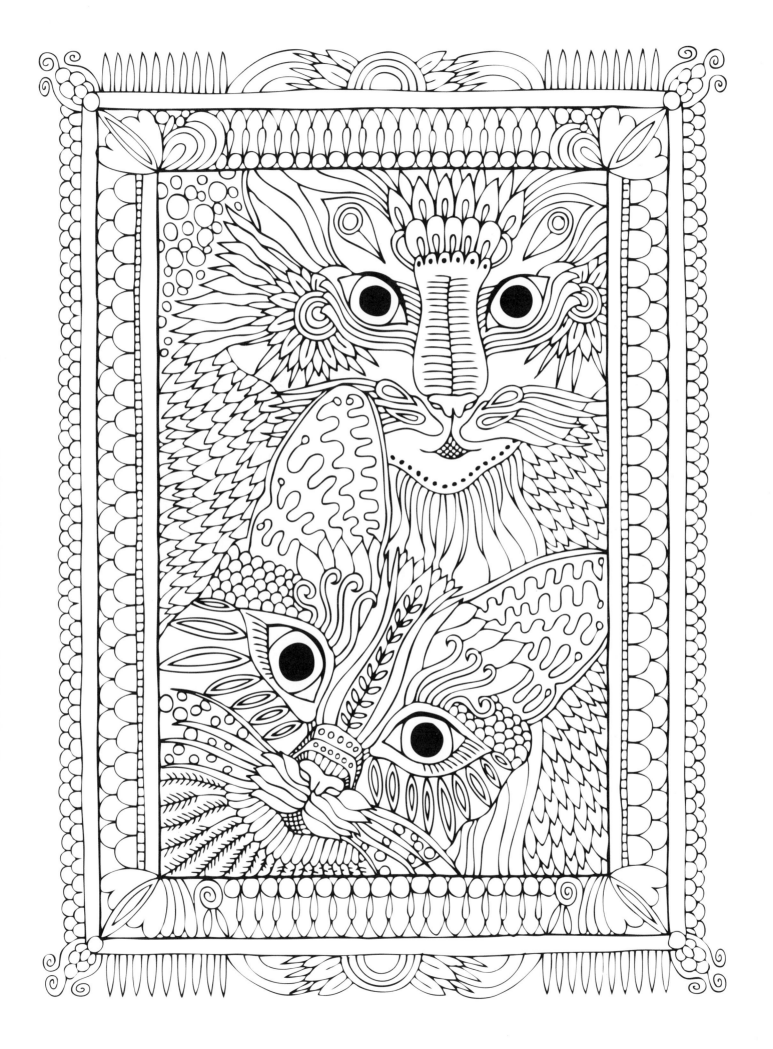

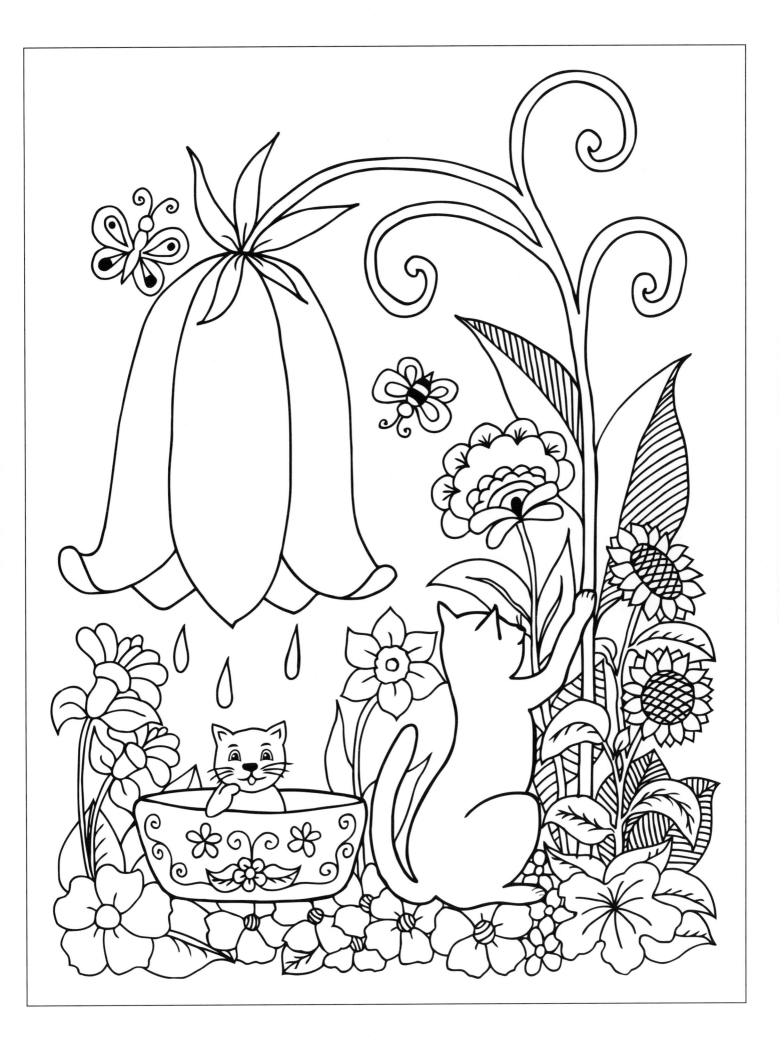

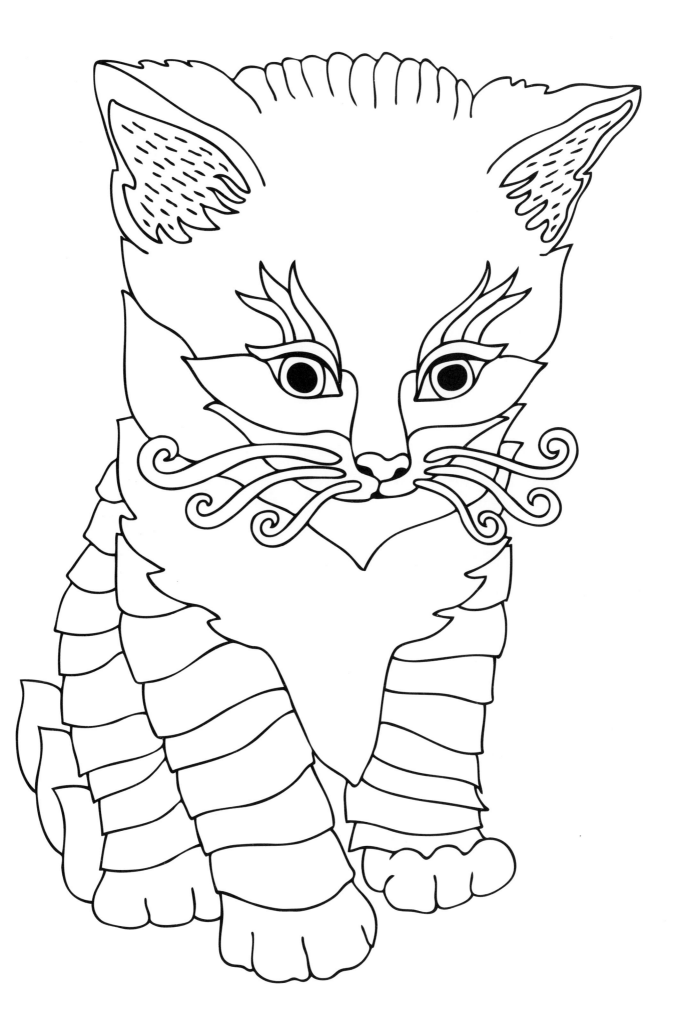

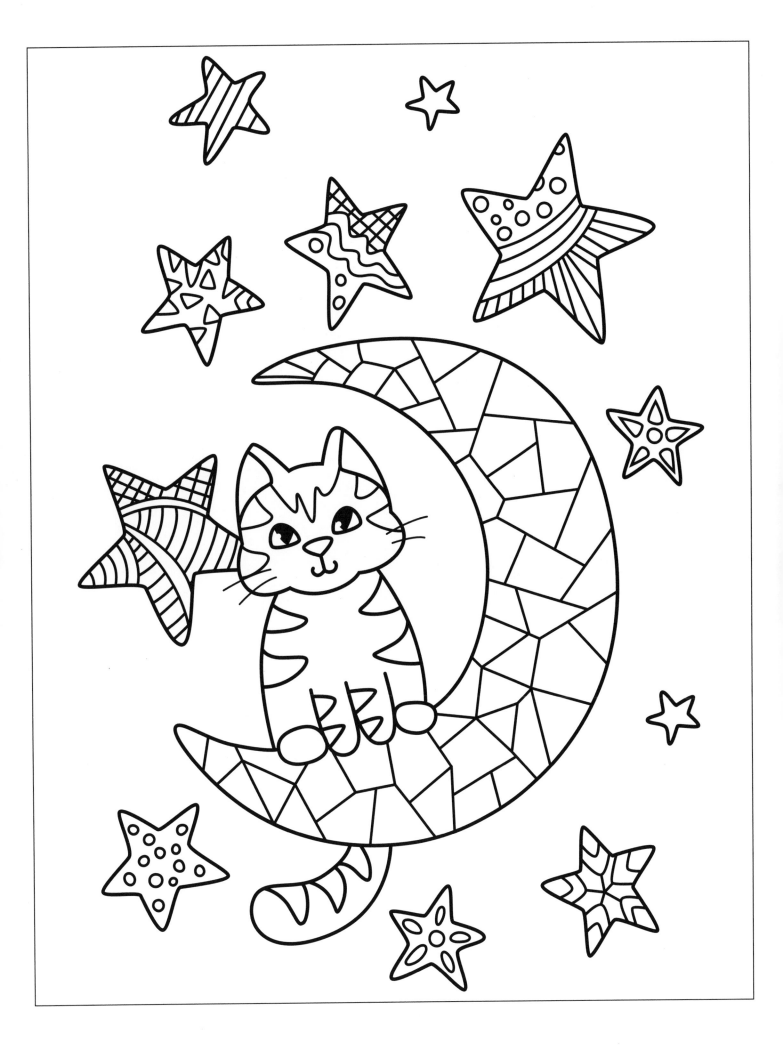

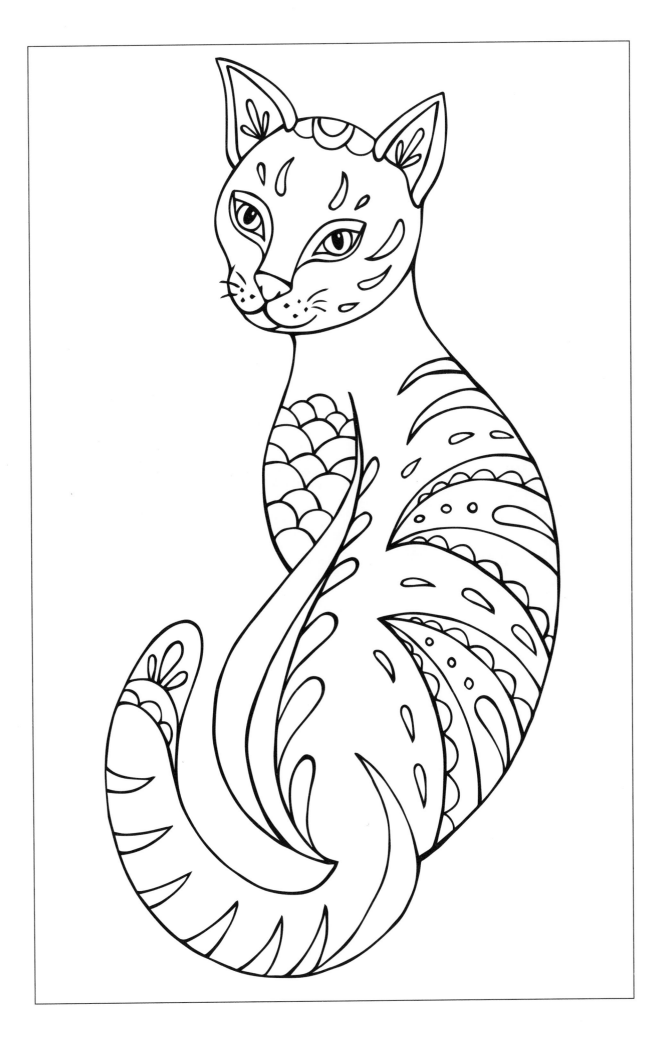

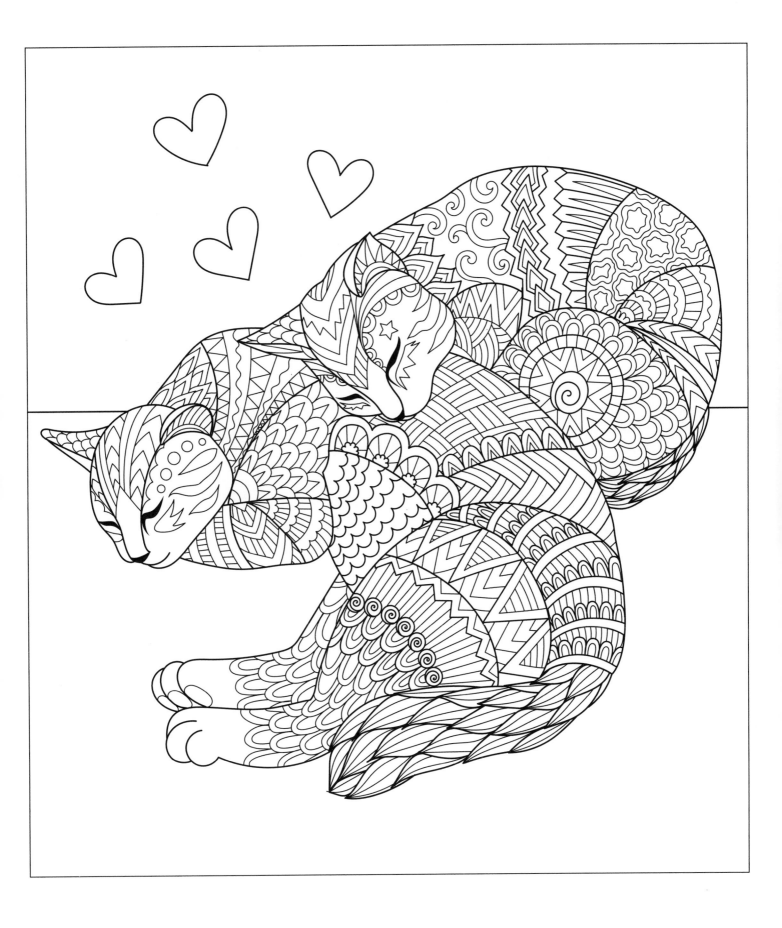

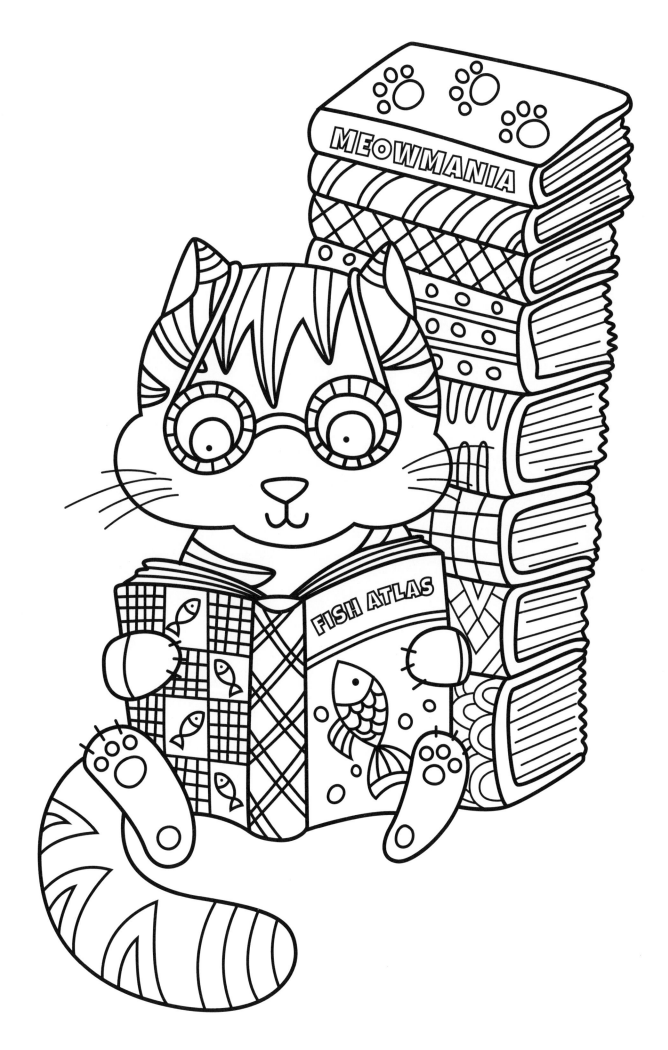

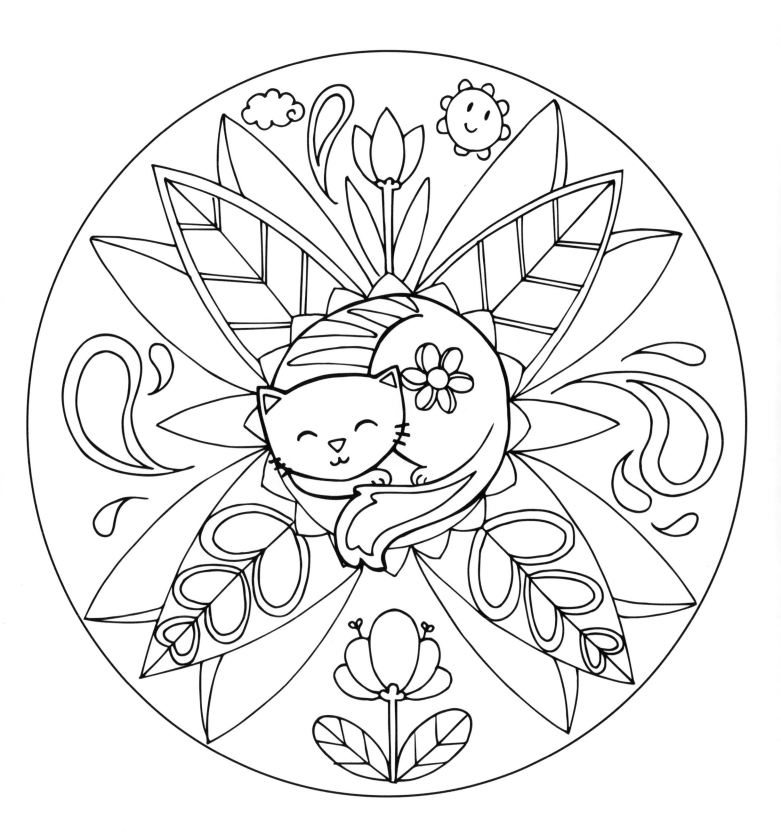

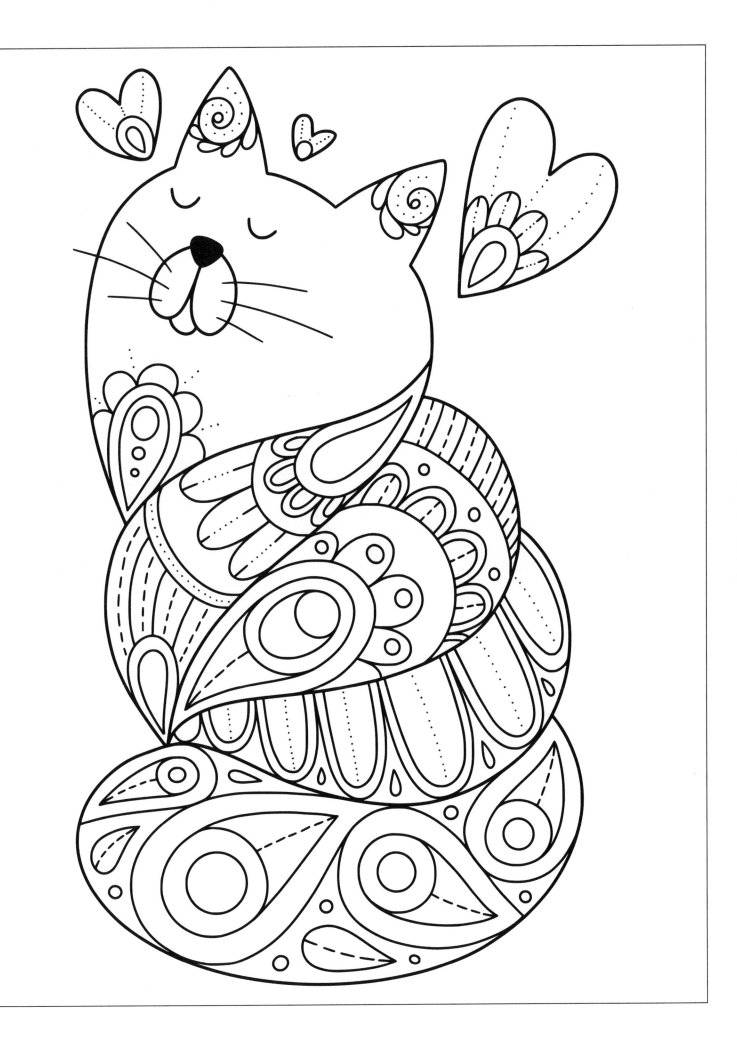

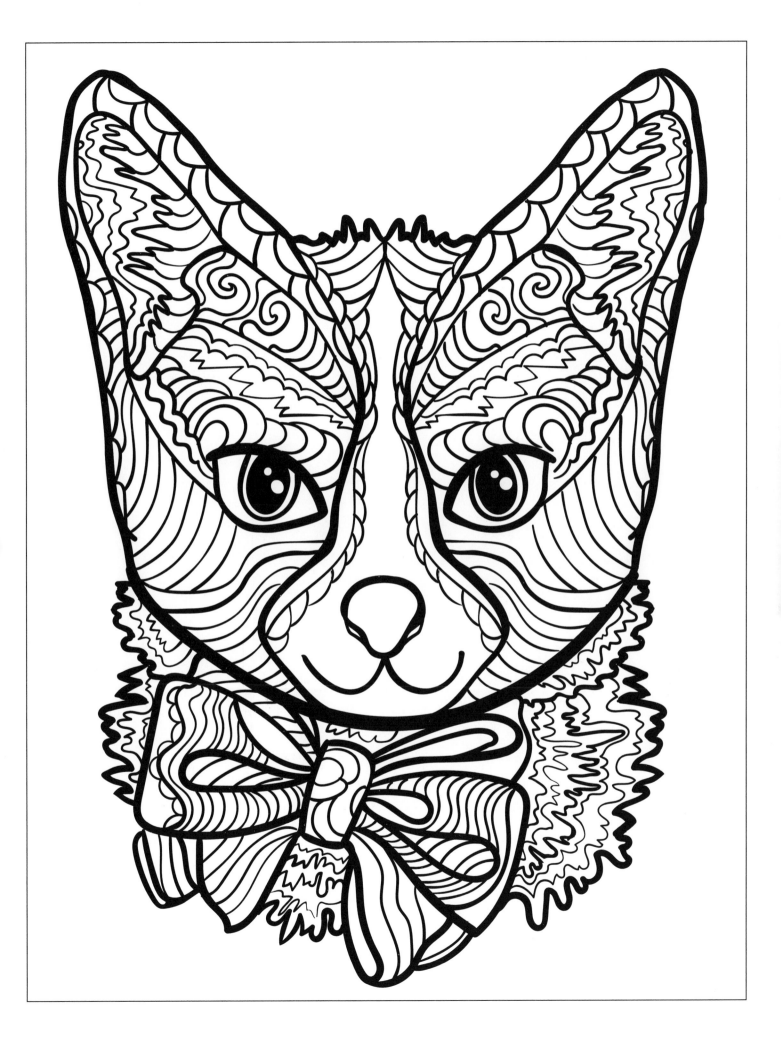

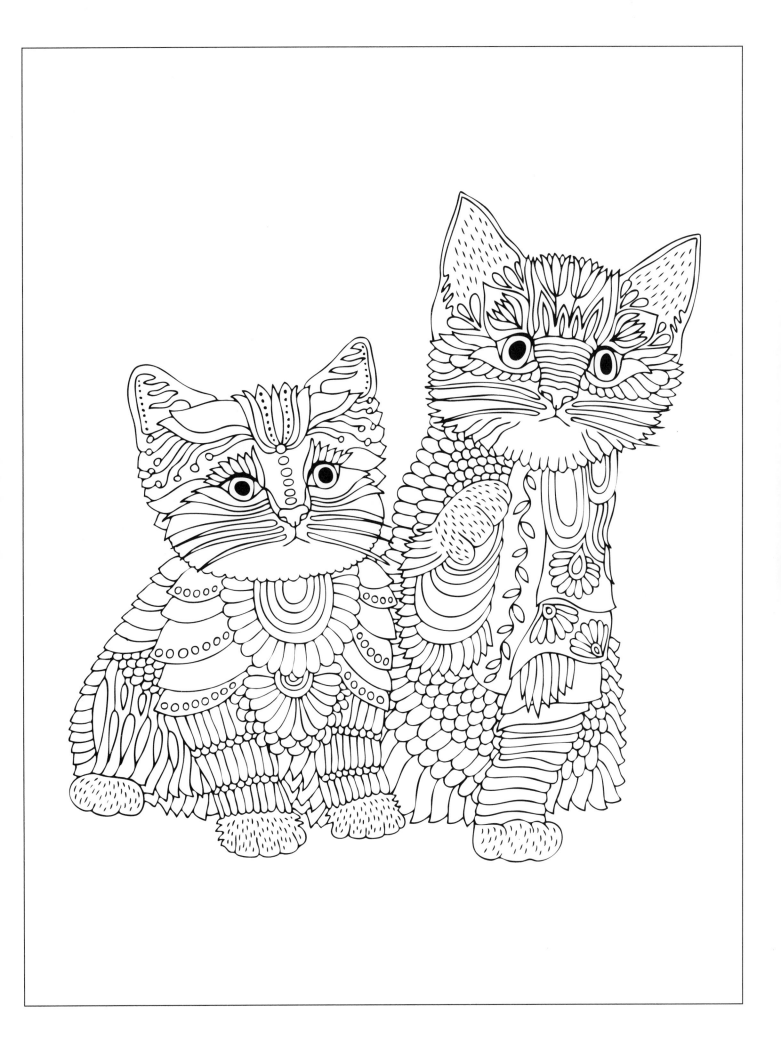

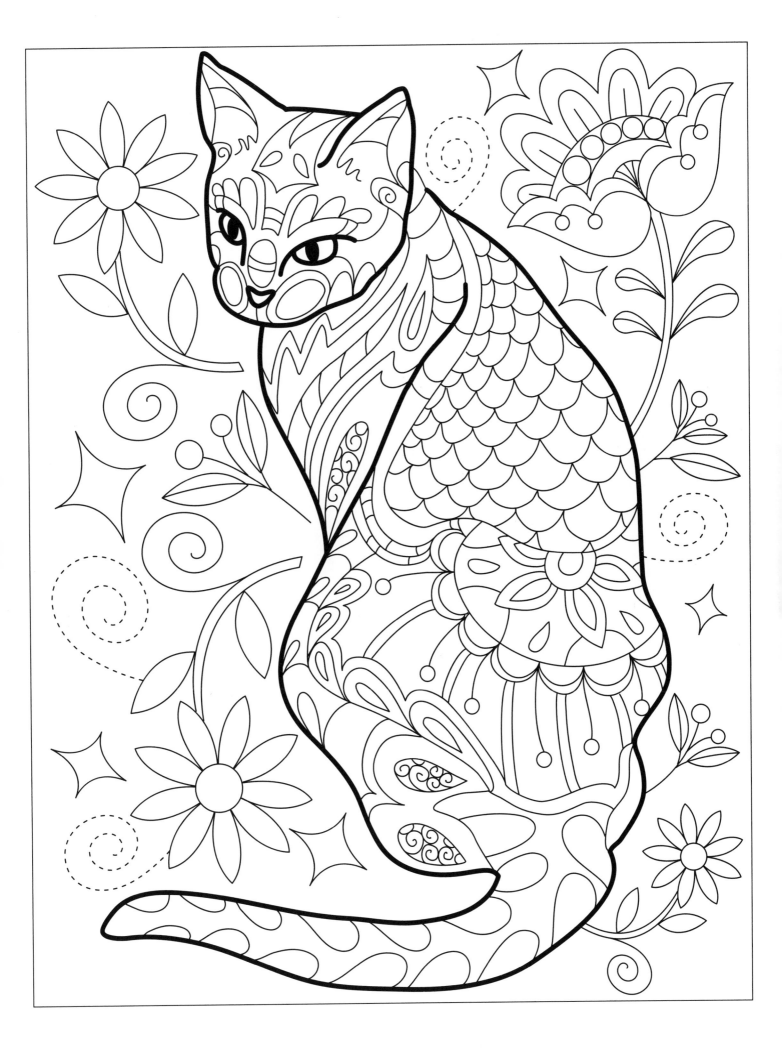

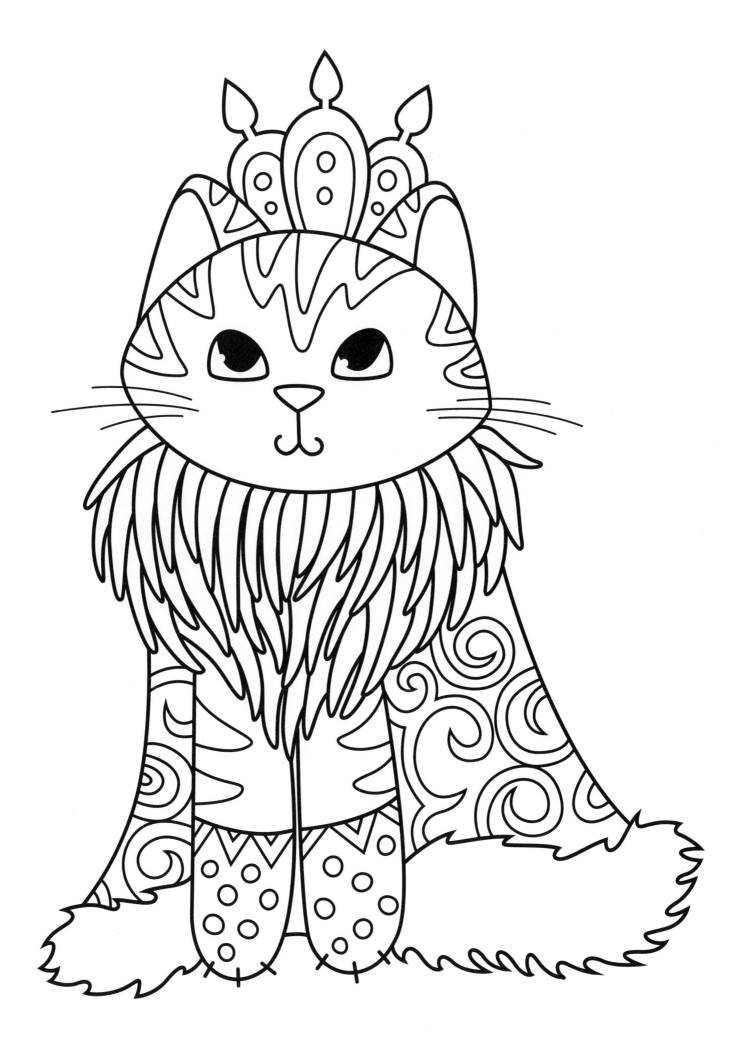

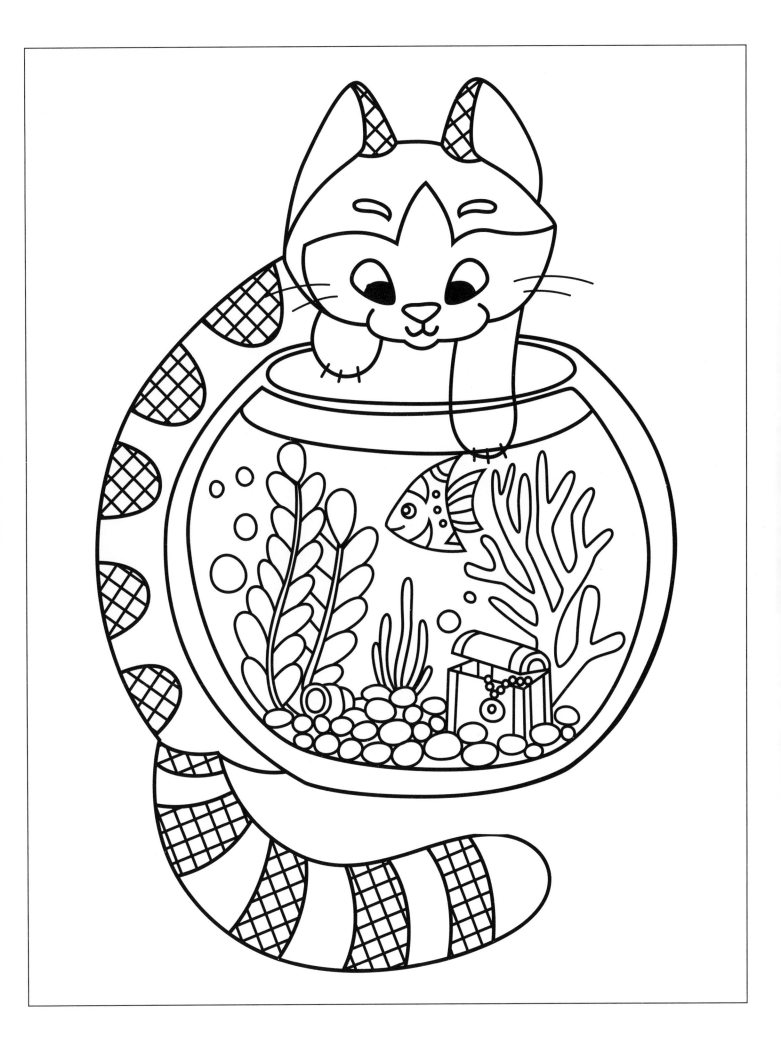

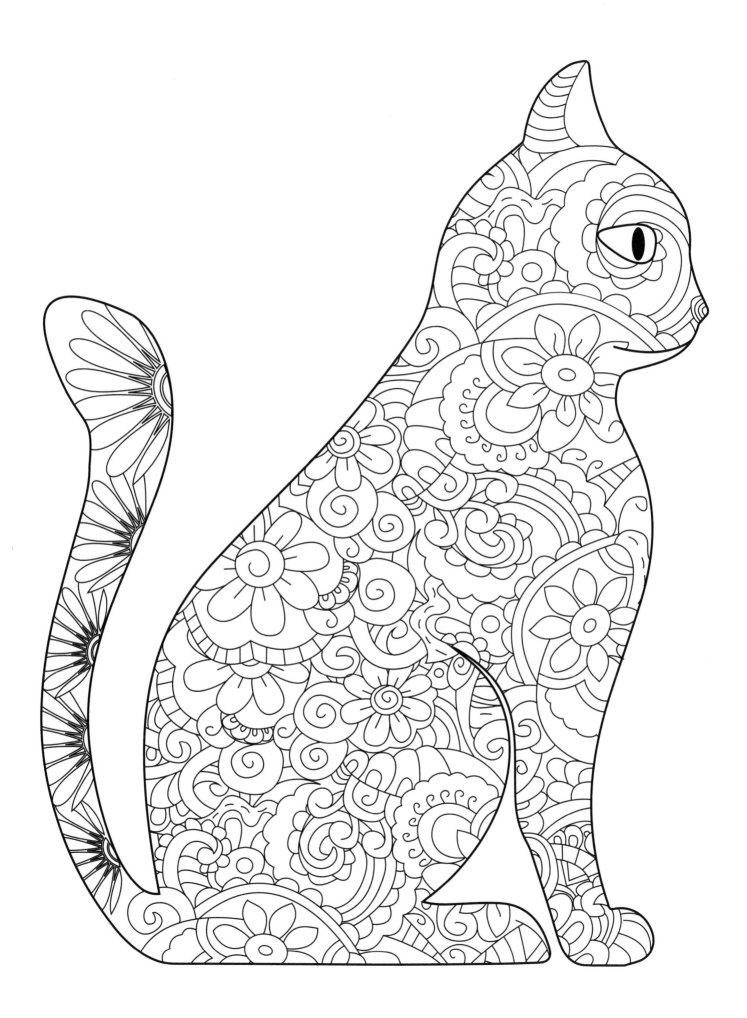

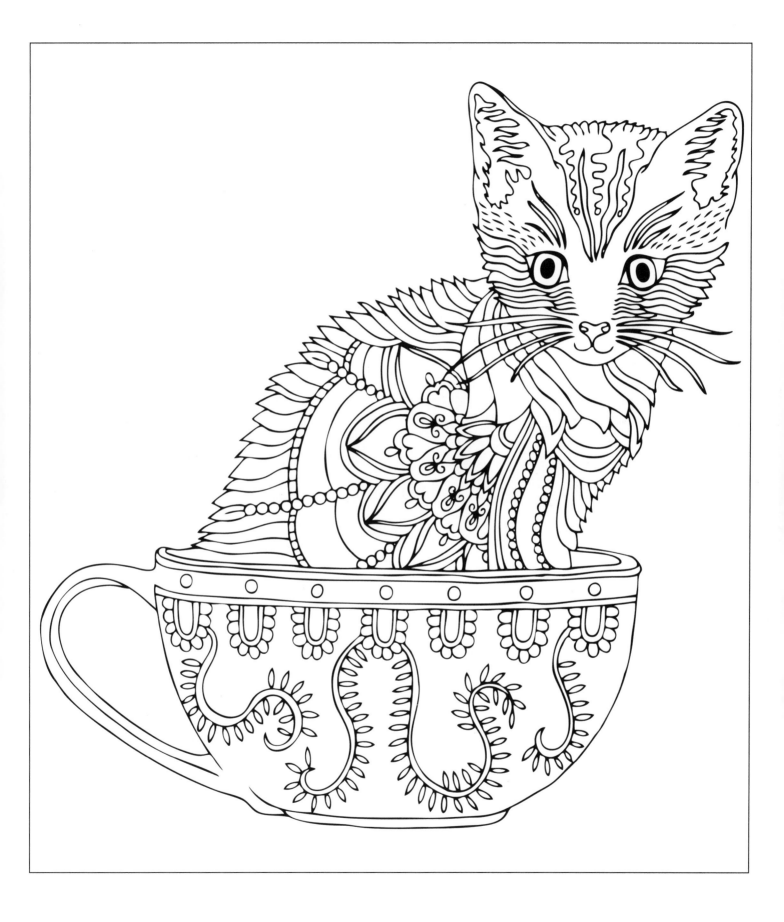

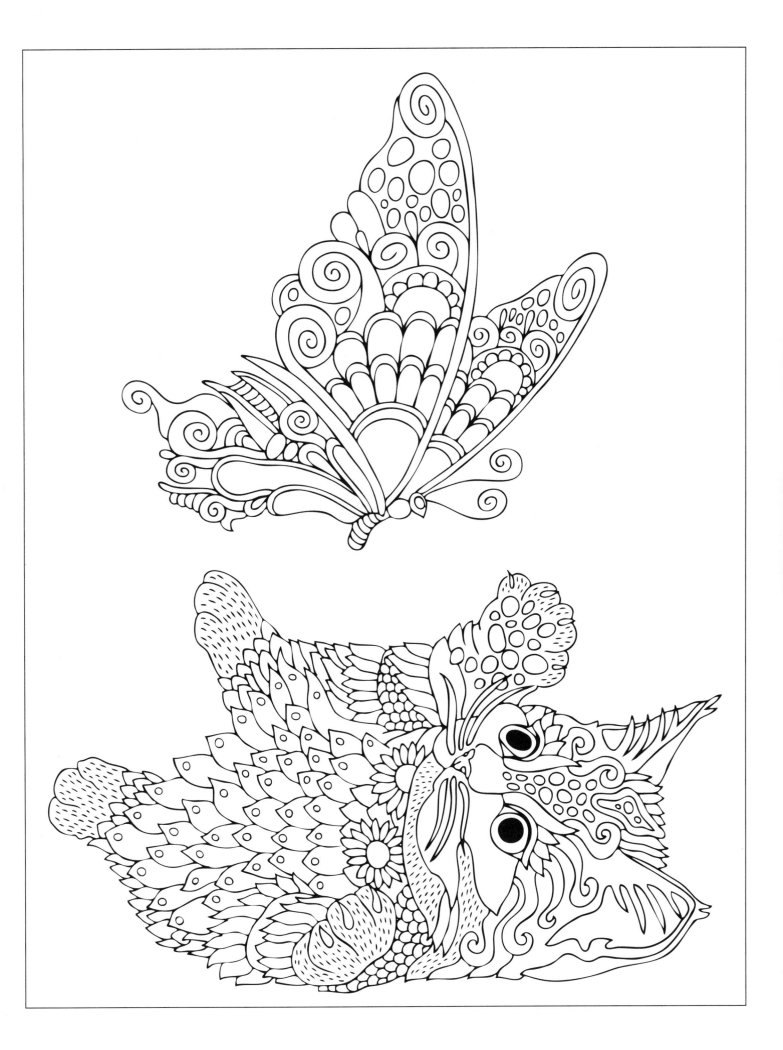

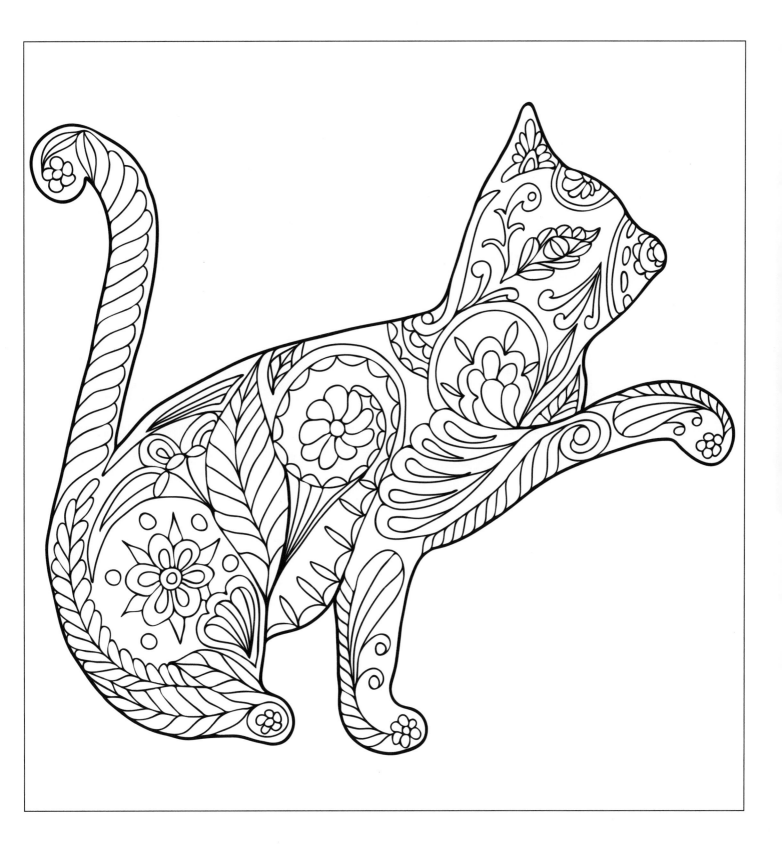

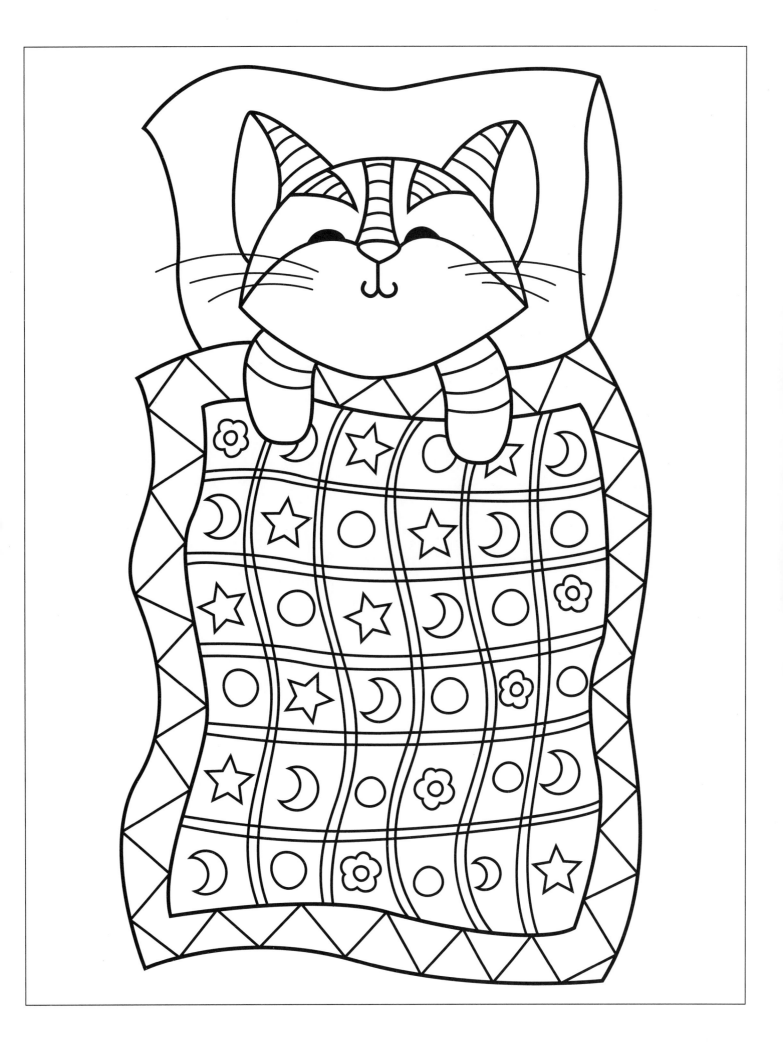

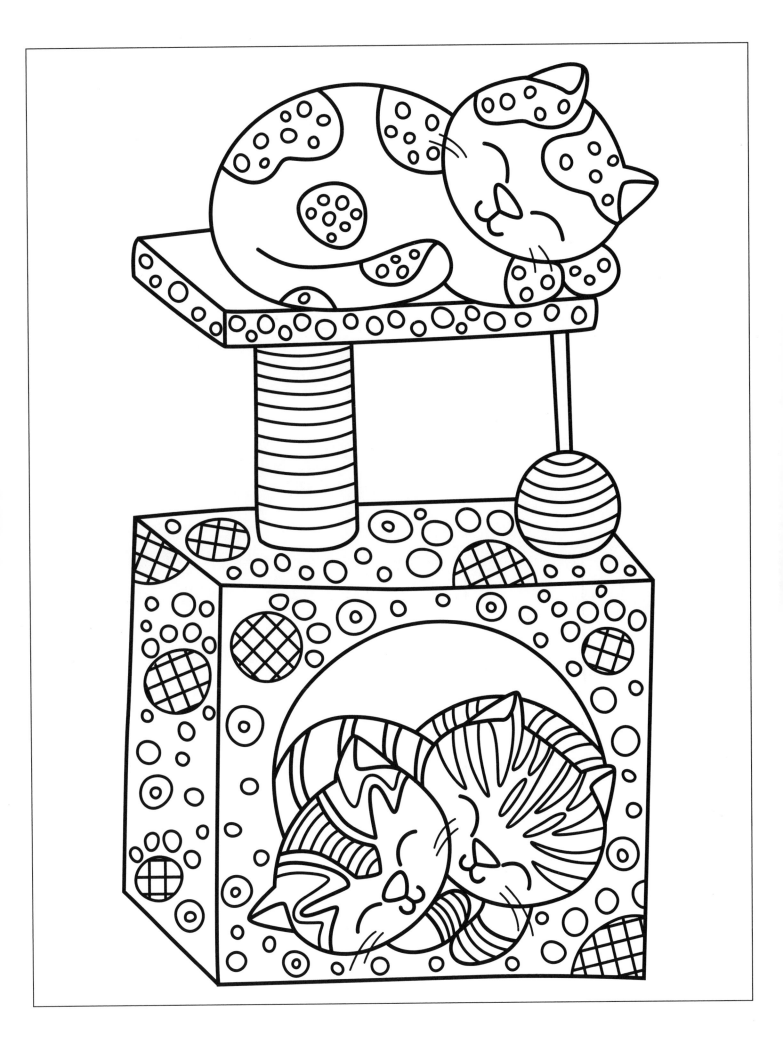

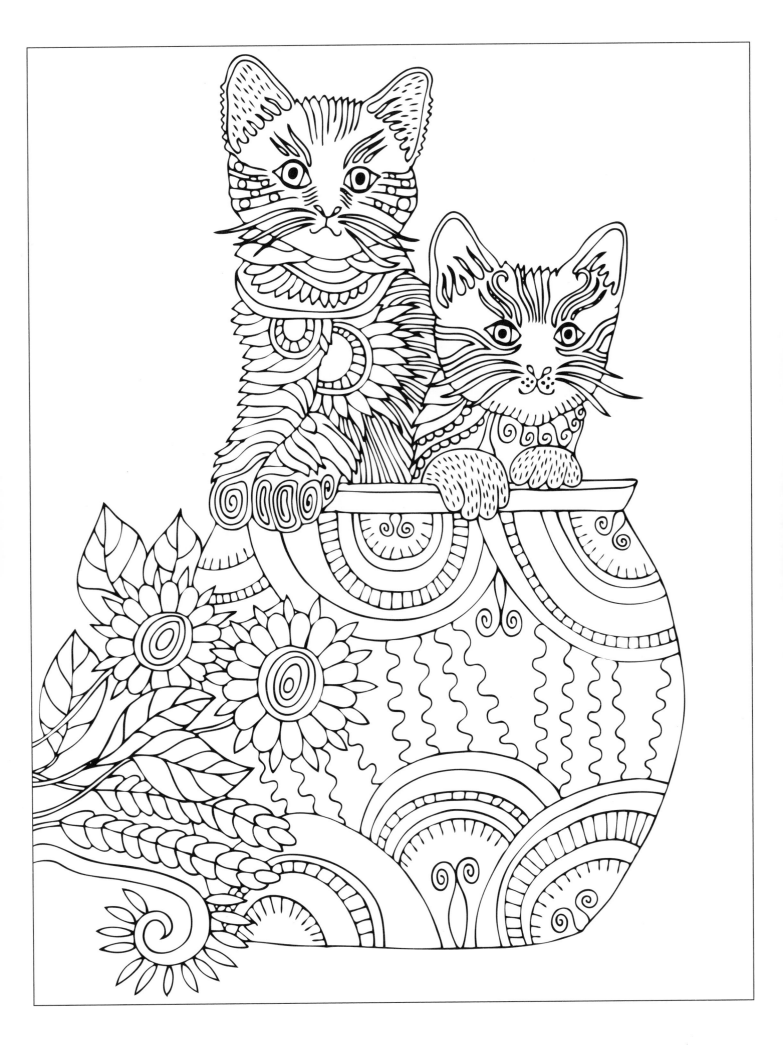

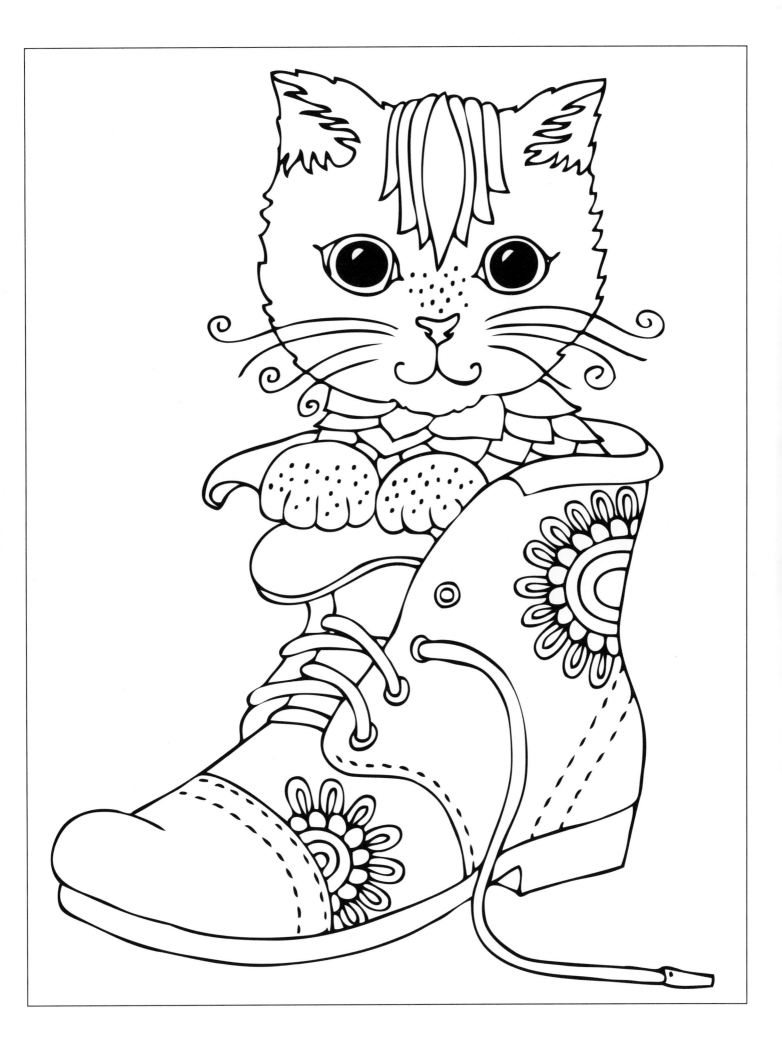

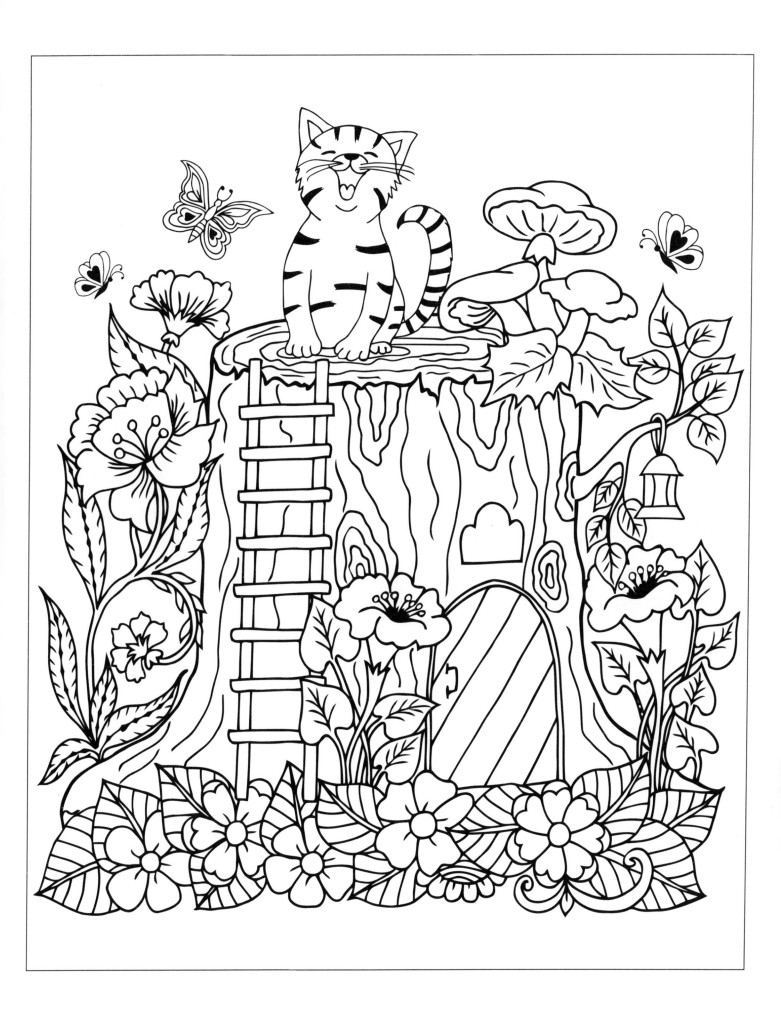